BYKER NEWCASTLE UPON TYNE

BYKER

NEWCASTLE UPON TYNE
in standard colour

photographs by Keith Collie
text by Sarah Glynn

Categorical

First published in 2015
by Categorical Books | 70 Margate Road | Herne Bay | CT6 7BH

Copyright © 2015 Keith Collie, images; Sarah Glynn, text
The pictures on pages 79 and 86 may be by Jeff Veitch

PICTURE EDITOR Nancy Wilson

ISBN 978-1-904662-22-8

A CIP record for this book is available from the British Library

MORE AT www.keithcollie.com

SARAH GLYNN is an architect, academic and activist with a particular interest in public housing. She has published numerous articles on housing policy and on 'regeneration', and edited (and wrote half of) *Where the Other Half Lives: Lower income housing in a neoliberal world* (Pluto Press, 2009).

CONTENTS

12 **GOOD HOMES** LESSONS IN PUBLIC HOUSING FROM NEWCASTLE'S BYKER ESTATE | Sarah Glynn

32 **BYKER** IN STANDARD COLOUR | Keith Collie

GOOD HOMES
LESSONS IN PUBLIC HOUSING FROM
NEWCASTLE'S BYKER ESTATE

Sarah Glynn

Public housing has been the victim of decades of government asset stripping and of negative propaganda that likes to portray it as a failed experiment. But the economic crisis and the iniquities, as well as the instabilities, of an economy based on property speculation have only highlighted how much it is needed. Affordable rented public housing could and should have a much greater role to play.[1] This is not to deny that there have been some very real problems – and we need to recognise these and learn from them – but, at the same time, we can point out the less headline-grabbing successes. We need to look at what has made public housing good homes in the past, and can continue to do so into the future.

Newcastle's Byker estate – which I first encountered as the paramount model of housing design when I was an architecture student and it was just being completed – provides an ideal history lesson. In concentrating on such an outstanding example, I do not mean to suggest that other public housing cannot make good homes. It can and does. But I do want to show both what can be achieved with a bit of extra investment in design, and also how

[1] For the argument for public housing see Glynn, Sarah (2014), 'Housing for a Better Nation', *Commonweal*, http://www.allofusfirst.org/library/housing-for-a-better-nation/

even the best-designed homes can suffer from poor maintenance and management and from wider political and socio-economic changes. Byker has been a Mecca for touring architects, a byword for multiple deprivation, and, recently, the subject of a 2∗ listing for architectural and historical importance, and of major plans for refurbishment. When it was listed, English Heritage explained, 'The Estate's groundbreaking design has been influential across Europe and has proved a pioneering model for its approach to public participation.'[2] So what can Byker teach us?

The Byker we see today was built in phases through the 1970s and consists of nearly 2000 homes on a 200-acre south-west-facing site overlooking the Tyne, about 1 $^1/_2$ miles east of Newcastle city centre. It replaced serried rows of Tyneside flats – terraces with separate homes (generally privately rented) on ground and first floors, and barren back alleys between small backyards containing outside toilets and coal sheds. The redevelopment came in the latter part of the great wave of slum-clearance schemes that created so much of our public housing. By 1968 there was a growing reaction against the disruptions of slum clearance, and Newcastle City Council was ready to give a positive response to residents' requests that their close community should be able to remain together in the new Byker. They appointed Ralph Erskine, who was then working on housing in nearby Killingworth but had chosen to set up his architectural practice in social-democratic Sweden, and he produced a much quoted design statement that read: 'The main concern will be for those who are already resident in Byker, and the need to rehouse them without breaking family ties and other valued associations or patterns of life.'[3]

2 Carol Pyrah, Planning and Development Regional Director for English Heritage, quoted on http://www.davidlammy.co.uk/da/49866
3 Quoted in Egelius, Mats (1990), *Ralph Erskine, architect*, Stockholm: Byggförlaget, p 151

Redevelopment versus refurbishment

With this statement in mind, the first thing I want to look at is the development process. Many neighbours were able to stay together, and this is an established and appreciated part of the Byker story; however, of the 12,000 people still living in Old Byker in 1968, only a minority were rehoused in the new scheme, which had fewer homes than before and was almost half occupied by people from elsewhere. This was partly the result of major delays in the building process; but Peter Malpass, who researched the redevelopment, put the blame firmly on the council, for whom the commitment to retain the community, despite its high public profile, remained a relatively low priority.[4] Many (especially young families) had also left before the start of the Erskine scheme, driven away by two decades of demolition plans and planning blight, and by demolition for a never-built motorway. Erskine attempted to co-ordinate rebuilding and demolition by reducing the number of homes demolished at any one time to around 250;[5] and, in response to the uncertainty caused by the building delays, the council was persuaded to allocate homes several months before they were completed.[6] Additionally, in 1974 the council started buying up homes scheduled for demolition so that they could ensure basic maintenance was kept up until the homes were empty.[7] All these things helped, but while the council's focus remained on the building process rather than the residents such measures could not be enough.

4 Malpass, Peter (1976), 'Rebuilding Byker: Twenty years hard labour'. Report on a research project carried out in the Department of Architecture Edinburgh University, typescript in Newcastle City Library; Malpass, Peter (1979), 'A reappraisal of Byker', *Architects' Journal* 9 and 16 May, http://www.architectsjournal.co.uk/archive/peter-malpass-on-byker-from-the-archive/5215878.article, p 964; Malpas, Peter and Murie, Alan (1999), *Housing Policy and Practice*, 5th edition, London: Palgrave Macmillan, pp 213–214

5 Ravetz, Alison (1976), 'Housing at Byker, Newcastle upon Tyne – Appraisal', *Architects' Journal* 14 April, p 736

6 Persuaded by the residents, architects and Community Development Officer; see Hills, Tony (1974), 'Community Development Officer's Final Report 1972–1974', typescript in Newcastle City Library, pp 4–5

7 See Hills (1974), pp 15–16

There are lessons here for future redevelopments, but there are also more fundamental questions about the desirability of redevelopment at all.

Whatever the quality of Erskine's Byker, it is difficult to justify the violent disruption of redevelopment. Besides effecting a significant break-up of the existing community, the demolitions were the cause of years of gross discomfort and worry for a great many people. This was sympathetically recorded by the photographer, Sirkka-Liisa Konttinen, who moved to the area in 1970 and lovingly documented the vanishing community,[8] and by Tony Hills, who compiled an angry report as Community Development Officer. Hills observed:

Practical problems such as the rapid deterioration of housing conditions, an increase in vandalism, burglaries, poorly maintained pavements and roads, go hand in hand with the emotional problem of frustration, loss of pride in home and neighbourhood, insecurity about the future.[9]

Emotional insecurity was combined with physical insecurity. People were scared to go out as homes were being broken into through the empty houses. Many suffered severe depression and anxiety. The local *Evening Chronicle* reported a planning officer describing people living in 'blitz' conditions, and criticism was raised in the House of Commons.[10] The planners of the recent mass demolitions (which have included large areas of Newcastle) appear to have forgotten the traumas of this earlier period.

Even after years of neglect, with the planners' axe held over them, the old houses retained the potential for a rolling programme of modernisation, and Erskine did consider renovation, but he claimed that this was not wanted and that the homes were beyond

8 Konttinen, Sirkka-Liisa (1985), *Byker*, Newcastle: Bloodaxe Books; http://www.amber-online.com/exhibitions/byker
9 Hills, Tony (ed.) (1973), 'The Social Consequences of Redevelopment', typewritten report in Newcastle City Library
10 Malpass (1976), pp 178–179

economic repair.[11] A 1968 survey reported that 80% of people supported clearance,[12] but the results of this type of survey depend on how the questions are asked and what the respondents understand about the options. Remaining undemolished streets adjacent to the estate are a testament to the solidity of the buildings, and there are, still, older residents who regret the loss of Old Byker.[13] Konttinen spoke to one man as he was packing up his home, who told her:

> It's wicked. These homes have been under demolition order for twenty odd year, and you know – they could've been saved ... They could've just given us a bath and hot water.[14]

They could also have carried out other improvements with some of the imagination shown in the new design. This might even have been achieved with less drastic rent rises: *Ideal Home* in 1976 gave an example of a household's rent going up from £1.50 in their old home to £9 (including heating) in their new one.[15] When Byker was being redeveloped, Camden Council in London was buying up blocks of Victorian terraces, upgrading the houses and slicing the ends off the back gardens so that the land could be combined into spacious and protected community gardens and play areas for all the surrounding homes.[16] Meanwhile, in Scotland almost 20,000 tenement flats were rehabilitated by local authorities or housing associations, and generally rearranged to provide fewer larger dwellings – often in opposition to earlier demolition plans.[17] This

11 Ravetz (1976), p 739; Erskine (1976), 'Designing with user participation', *RIBA Journal* 84:7, p 273; Erskine (1984), 'Designing between Client and Users' in Hatch, C. Richard (ed.), *The Scope of Social Architecture*, New York: Van Nostrand Reinhold, pp 188–193. Though Erskine (1976) also mentions people refusing to move
12 Ravetz (1976), p 739; *Architectural Design* 11–12 (1977), p 838
13 Conversations at the Byker Community Centre Lunch Club, 26 January 2015
14 Konttinen (1985), p 8
15 *Ideal Home*, March 1976. Erskine recognised the potential hardship this could cause and called for greater economic opportunities for the tenants and the possibility of subsidies; see Erskine (1977), 'Participating in Byker' in *Architecture: opportunities, achievements: a report of the Annual Conference of the Royal Institute of British Architects held at the University of Hull, 14 to 17 July 1976*, London: RIBA Publications (74–76), p 76
16 Information from residents, John Twigg and Angela Inglis
17 Gibb, Andrew (1989), 'Policy and politics in Scottish housing since 1945' in Rodger, Richard (ed.), *Scottish Housing in the Twentieth Century*, Leicester: Leicester University Press,

could even be done piecemeal without the occupants having to move out.[18] The possibilities of refurbishment, as well as the institutional resistance to it, are further demonstrated in Rod Hackney's account of how he and his neighbours saved their terraced houses in early 1970s Macclesfield.[19]

More recently, the residents of Longford Street in Middlesbrough have demonstrated what can be done with a back alley similar to those in Old Byker. After the local Neighbourhood Trust had fitted gates to deter anti-social behaviour, Mavis Arnold, who has lived in the street since the 1960s, applied for a small grant for garden materials and rallied her neighbours to create a hidden garden that has become, in her own words, 'a very safe and very well-used community space' for both adults and children.[20] The Longford Street garden has received wide publicity and has inspired further projects in other Middlesbrough back lanes.[21] Another determined and green-fingered woman, Eleanor Lee, has been the driving force behind the ongoing transformation in the Granby Triangle in Liverpool. The greening of Cairns Street began as a defiant response to years of neglect and threatened demolition. Residents went on to organise a monthly market among the plants, and have now managed to set up their own community land trust that is bringing boarded-up homes back to life.[22]

p 175. There was even a short promotional film made for Glasgow Corporation in 1974, entitled *If Only We Had Space*; see Scottish Screen Archive, http://ssa.nls.uk; and the upgrading of Duke Street Glasgow was covered in the second series of the BBC's *The Secret History of our Streets*, broadcast 1 August 2014

18 Young, Raymond (2013), *Annie's Loo: The Govan Origins of Scotland's Community Based Housing Associations*, Edinburgh: Argyll Publishing

19 Hackney, Rod (1988), *The Good, the Bad and the Ugly*, London: Frederick Muller, Chapter 4, 'The Battle of Black Road'

20 See video in Duell, Mark and Harding, Eleanor (2013), 'Gardening? It's right up our alley! Community transforms Victorian passageway behind homes into oasis of greenery', *Daily Mail*, 20 August 2013, www.dailymail.co.uk/news/article-2397899/Community-transforms-Victorian-passageway-Middlesbrough-homes-oasis-greenery.html

21 Some have been more successful than others, depending on the permanency and commitment of local residents. The idea has been taken up by One Planet Middlesbrough

22 The residents in this case are low-income home owners. See the Trust website, www.granby4streetsclt.co.uk; Glynn, Sarah (2009), *Where the Other Half Lives*, London: Pluto, pp 308–309.

All sorts of housing – including the big brutalist schemes of the 1960s and 1970s – has the potential to provide good modern homes with a bit of investment and imagination, including in the landscaping. Developments such as Urban Splash's Park Hill in Sheffield give an idea of what is possible,[23] but these improvements should be being done for the benefit of existing social tenants and not as part of a speculative scheme involving large-scale privatisation and gentrification.

Realities of participation

Before looking at the design of what is still referred to as New Byker or the Redevelopment, I also want to examine wider issues around its much praised public participation. The rhetoric of participation was in the air – the Report of the Committee on Public Participation in Planning, prepared by Arthur Skeffington MP, was published in 1969 – and Erskine's approach was regarded as 'pioneering'. However, not only were the majority of the tenants of Old Byker excluded from relevant debate since they were rehoused elsewhere, but, as Malpass showed,[24] although there was consultation, it is dangerously misleading to regard this as an example of participatory practice. The architects had an office on the site where people were free to drop in and raise their concerns (which were often only loosely connected to the buildings and generally focused on when they would be rehoused), there was a liaison committee (initially invitation only), and council officers held meetings on the site; but, despite Erskine's egalitarian ideals, this was consultation on the council's terms. Power remained with the council, and the council rather than the tenants remained the real client. Tony Hills observed:

23 *The Architectural Review* October 2011, http://www.architectural-review.com/issues/october-2011/a-second-chance-for-sheffields-streets-in-the-sky/8620160.article; Levitt, David (2012), 'Park Hill: the facts', in Collie, Keith, Levitt, David and Till, Jeremy, *Park Hill Sheffield*, Canterbury: Categorical Books
24 Malpass (1976 and 1979)

BYKER NEWCASTLE UPON TYNE

> What is happening in Byker is largely an example of an intractable social and technical problem being handled by a Local Authority and other professionals with a lot of sensitivity and concern. At various stages people have been consulted about possible changes, and at others the expressed wishes of local people has been allowed to modify policy and practice. All this is admirable and in many ways successful, but it is not participation.[25]

The onsite office did allow for responsive and sensitive project management; but the main project architect, Vernon Gracie, who lived above the office in Byker, claimed on behalf of the architects 'only... a modest advance in humanizing the processes of redevelopment'.[26]

I wouldn't want to discourage even limited consultation, but it has to be seen for what it is. And Malpass rightly highlighted how this type of approach can be used as a management tool to sideline dissent. Recent regeneration schemes have reinforced his point – and shown how this tool has been refined. Energies are directed into an agenda set by the authorities, the rhetoric of participation sugars some unpalatable decisions, and alternative views are dismissed as disruptive of the consensus. When the lack of real power mattered most for Byker was the tenants' inability to force the council to *prioritise* retention of the community and so reschedule the demolition programme to co-ordinate with the new building, as envisaged by the architects: especially as the place and time of their rehousing – rather than design details – were the issues uppermost in most people's minds.

The housing that had the greatest direct tenant input into its design was probably some of the least successful. This was the pilot scheme, and while care was taken to learn lessons from it so as to improve subsequent homes, its tenants came to resent their guinea-pig role.[27] The aspect of this design approach that was arguably

25 Tony Hills (1974), p 22
26 Gracie, Vernon (1984), 'Pitfalls in Participation: A Cautionary Tale (of Success)', in Hatch (1984), p 197
27 *Architectural Design* 11–12 (1977), p 840. Erskine was very aware of this and observed: 'Finance should be made available so that you can go back later and make improvements to

the most successful was the continued informal day-to-day contact with the architectural team. The architects could observe the community around them, the tenants could respond directly to what was happening, and it all fed into the design brief. Architecture can't be designed in public meetings, but good architecture is the product of a sensitive and inspired response to a well-researched brief.

New Byker

New Byker is characteristic of Erskine's style, at the same time as responding to the site and its residents' needs. It is egalitarian and without pomposity, and pays careful attention to climate and sunlight. It combines a practical humanism with a quirky delight in design and an attention to detail that lifts it way above more utilitarian responses – even though some of the original workmanship was unforgivably shoddy.[28] The redevelopment was both a product of its time and a leading example of urban design. Important elements of the plan were already being discussed before Erskine was asked to take over. A 1967 report by the Council Architect proposed a traffic-segregated scheme, the retention of key buildings such as churches, and a wall of flats to protect the estate from the noise of the proposed new motorway to the north.[29] However, the protective wall had long been a recurring theme in Erskine's work – especially in designs for Arctic settlements, but also in his housing in Tibro, designed in 1959, where he had already shown how access balconies could be humanised with seating and planters. Erskine's design kept more of the old communal buildings, and it also encouraged community solidarity through its careful planning and detailing of the spaces between the housing.

The northern edge of New Byker is formed by the famous Byker Wall, a snaking block of flats and maisonettes creating a bar-

the early scheme.' See Erskine (1976)
28 *Architectural Design* 11–12 (1977), p 841
29 Cunningham, D.H. (1967), 'Byker Redevelopment Area Initial Study. Report to Housing Committee', March 1967, Newcastle City Council

rier to noise, and also to the winds from the North Sea, that is up to eight storeys high in places. The Wall turns an almost blank façade to the major road that was intended to be upgraded to an urban motorway, and the outer brickwork is pierced only by small kitchen and bathroom windows and baffled ventilators. To the south, the Wall breaks out into a seemingly random array of timber-slatted accessways, sunny balconies and planters. At the bottom are maisonettes with small private garden spaces for families, and above – for households without children – are two-storey flats with views across the Tyne. Within the protective Wall are acres of low-level high-density housing. Each area has its distinct characteristics and bright colours, and a careful hierarchy of small private gardens (70% of the homes were designed with their own garden space for families), semi-public communal spaces overlooked by the surrounding homes, and bigger or more open spaces. The site planning makes utmost use of sunlight and views. Main paths run along the contours and smaller links provide shortcuts and variety. Access roads and car-parking are kept segregated in the background, including on the far side of the Wall. Landscaping is integral to the design and has all been meticulously and imaginatively planned, incorporating salvaged paving and architectural fragments from the demolished town hall. While some areas are clearly more successful than others, the general result is unashamedly picturesque and village-like, and excites real enthusiasm in many residents as well as among visiting architects.

Construction of the low-rise housing is timber frame with brick cladding. This was relatively quick and cheap to erect, and interest and overall coherence were achieved through the varied use of a palette of basic inexpensive elements such as timber slats, which extended into the landscaping. Internal layouts are generous, and more conservative planners were surprised by tenants' appreci-

ation of open plans and bright colours[30] – though, predictably, the major source of enthusiasm for most tenants was the modern facilities that we now take for granted.[31] (The homes are bigger than they appear from outside, perhaps partly because of the use of larger specially commissioned metric bricks that can distort our sense of scale.) Everything is heated by a communal heating scheme – an arrangement that is particularly prevalent in the Nordic countries – and the heating ducts add to the idiosyncratic geometries.

Erskine was a strong proponent of mixed-use development, and his initial design statement referred to a 'complete and integrated environment for living in its widest possible sense'.[32] This was to include shopping, recreation, studying, and – where possible – work. He also observed that:

> people wanted their corner shops, pubs, laundries and the Shipley Street Baths, all of which were scheduled for demolition. They wanted functional spaces that were also places for meeting friends and neighbours, places 'for a good laugh' as well as for practical use.[33]

Many community buildings were preserved, others were rebuilt so as to give a more even distribution of facilities,[34] and the development included corner shops (with subsidised rents) and numerous 'hobby rooms' that were free for a whole range of uses. Organisations such as the working-men's clubs remained in place, and the old buildings helped root the new development, while providing architectural contrast and strengthening the village feel. The small industrial area in the south-west of the site was kept, and workshops were included by Raby Cross.

30 *Architectural Design* 11–12 (1977), p 839
31 *ibid.*, p 838
32 Quoted in Egelius (1990), p 151
33 Erskine (1984), p 188
34 *Architectural Review* 156 (1974), p 346. Byker as built varies quite a bit from the plan in this article, including the position of the main shops, which were built further down Raby Street

BYKER NEWCASTLE UPON TYNE

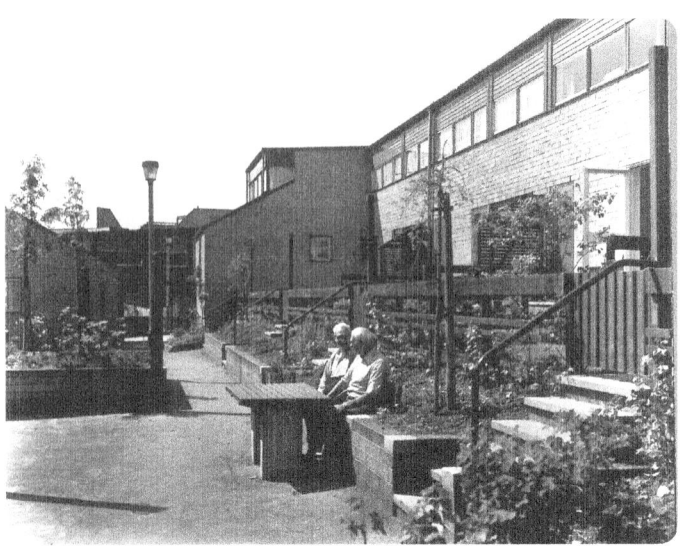

A semi-public space photographed by the City Engineer in 1975 (Newcastle City Library, L942.82 N537B)

'Life Between Buildings'

The attention to landscaping and to the creation of spaces that promote everyday social interaction and a degree of shared open-air living would be enough in itself to set Byker apart from other British housing schemes, and deserves much greater recognition.[35] British planning had tended to respond to the growth of car ownership through variations of the Radburn plan (named after an uncompleted 1929 settlement in New Jersey) which introduced a schizophrenic system of cul-de-sacs with vehicular access on one side of the house and pedestrian access on the other, or through garage courts, deposited, like the buildings they served, in a minimally landscaped green park. Neither arrangement encouraged casual meetings or the use of public space. By contrast, Erskine's early training in equality by Fabian parents and a Quaker school, and his practice in garden-city planning, had developed in the fer-

35 There was an enthusiastic contemporary critique by Peter Buchanan (1981), *Architectural Review* 170, pp 334–343

tile soil of Swedish social democracy to make him a leading proponent of Nordic ideas on building for communities. He explained that the Byker plan came out of 'previous experience of social-psychological studies and user reactions'.[36] The careful gradation from private to public, the small front gardens with low fences, and the well defined semi–public shared open spaces are a built illustration of the ideas discussed in Jan Gehl's *Life Between Buildings*, which was first published in Danish in 1971. The English edition of Gehl's book, which came out fifteen years later, included photographs of Byker and a preface by Erskine where he described it as 'a great inspiration to me'.

If Byker were in Sweden, each of those semi-public spaces would be equipped with children's play equipment, and early photographs of the estate do show play equipment in Byker. Erskine observed:

[W]e find that British children, like all others, enjoy swings, and sand, and water-play places, while grownups and parents will not have them for reasons good and bad – dogs fouling, noise, mess... We therefore planned rather inadequate facilities for children, leaving space for further provision. But we built a functioning and dog-free playground that included guinea pigs, sand, climbing frames, trees, etc., outside our office and trusted that the message would get home. This method did prove successful, and we are now asked to equip areas better for the children.[37]

The shared garden spaces were dotted with play shelters as well as with L-shaped seats, designed to facilitate conversation.

The planting, which included much more shrubbery than remains today, was integral to the design, and carefully thought out both aesthetically and practically. One of the first development activities was the establishment of a tree nursery; plants were used to protect vulnerable architecture, and granite kerbs were used to

36 Erskine (1984), p 192
37 *ibid.*, p 191

BYKER NEWCASTLE UPON TYNE

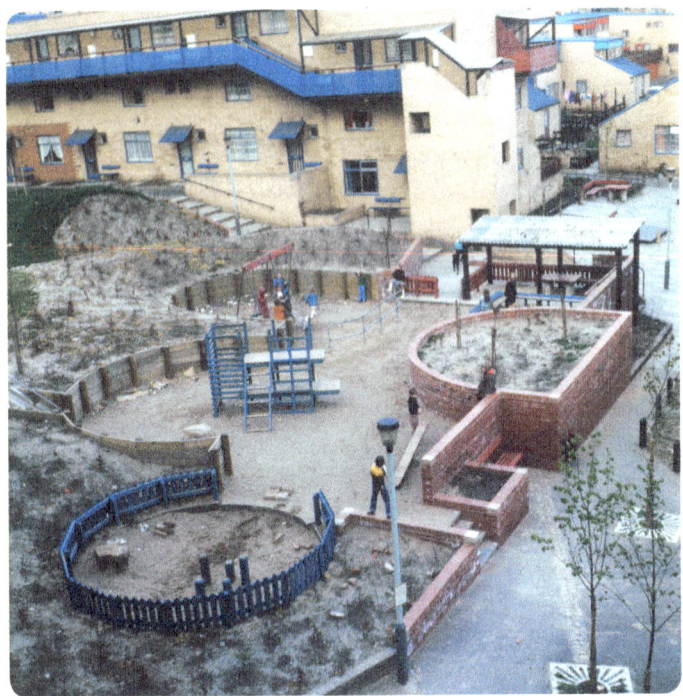

A newly built and planted play area photographed in the 1970s (Tyne and Wear Archives DX1256/2/5)

protect plants.[38] The architects' on-site office sold plants cheaply, and tenants who dug their own gardens were offered plants in lieu of the saved costs. Landscape architects were available to give free advice, and they produced a gardening manual that was given to all tenants. While this raises echoes of earlier paternalistic managerial practices,[39] a careful balance was struck between control by the municipality and opportunity for, and encouragement of, individual innovation. So, for example, the dustbin shelters had planters on top that were planted by the council but could be replanted by tenants;[40] and beech hedges set on the public side of garden fences

38 Buchanan (1981)
39 Ravetz, Alison (2001), *Council Housing and Culture: The History of a Social Experiment*, London: Routledge, pp 118–119
40 Ravetz (1976), p 12

BYKER NEWCASTLE UPON TYNE

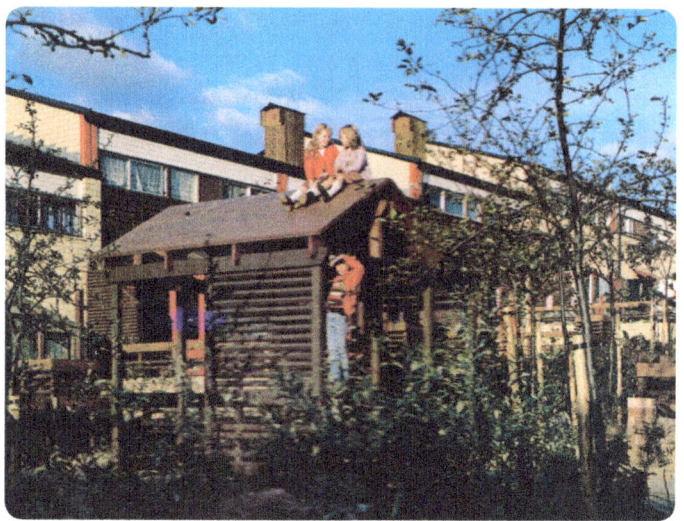

A play shed photographed by Jeremy Preston for the *Architectural Review*, 1981

could be trimmed to their preferred height by those who lived behind them.[41]

Where it was less successful

Not that everything worked as hoped. As has been found elsewhere, old hierarchies proved hard to shift,[42] and stigmatisation of the lower area, closer to the riverside industries, was carried over from Old Byker to New.[43] The architects tried to cut across this by moving their planned shopping centre further down Raby Street,[44] but although Raby Cross originally included a doctor's surgery and meeting rooms and was a short walk from the old library, it seems never to have been very successful,[45] as well as being architecturally banal. Residents from Old Byker still mourn the loss of Raby

41 Buchanan (1981), p 340
42 Robertson, Douglas (2013), 'Knowing Your Place: The Formation and Sustenance of Class-Based Place Identity', *Housing, Theory and Society*, 30:4, pp 368–383
43 Egelius (1990), p 151
44 Gracie (1984), p 194
45 Abrams, Robin (2003), 'Byker Revisited', *Built Environment* 29:2, p 123

Street as a full, busy shopping street where you could get all you needed: 'a city itself when I was a bairn', as one described it to me. For residents higher up the hill, Raby Cross was never going to compete with Shields Road, outside the Wall and across the putative motorway and 1980s metro. The new swimming pool and library near the metro station, as well as the Morrisons supermarket in Shields Road, have only consolidated the centre of gravity outwith the estate, emphasising the unsatisfactory relationship between Byker as a walled citadel and the surrounding area.

A significant complaint about the houses themselves is the inadequate acoustic separation between dwellings – despite improvements following the pilot development. Some people also feel too closely overlooked by their neighbours. And, although communal heating has the potential to be economical in both financial and environmental terms, the Byker installation is not. Houses at the end of the pipe run are poorly served, and heating costs are the same however much heat is used so there is little incentive not to have the system full on and the windows open. Charges have often been much higher than for conventional central heating. Currently, unemployed tenants have to spend nearly a third of their Jobseekers' Allowance on their heating bill[46] (which is not covered by Housing Benefit). There have been other problems too. A pioneering conversion using incinerated waste had to be brought to an angry close after years of campaigning by local residents whose children were suffering from asthma attacks.[47]

Despite such problems, and its troubled birth, New Byker succeeded in demonstrating the value of a dedicated and humane approach to the design of public housing – and tenants enjoyed showing off their new homes to visiting architects and planners.[48]

46 As Ken Milor pointed out to me
47 *Evening Chronicle*, 29 January and 4 November 2003; Konttinen, Sirkka-Liisa (2009), *Byker Revisited*, Newcastle: Northumbria Press, p 18
48 *Architectural Design* 47:11–12 (1977), 'Profile Ralph Erskine: the humane architect', p 837, described tenants arguing over whose turn it was to show visitors round

They put their own money into parquet floors and better kitchen cupboards, and their energy into their gardens.[49] In 1980 Byker was chosen as 'best kept village' in the Britain in Bloom competition;[50] and the estate was held up as an example of a 'comparatively vandal-free community'.[51] But attitudes to public housing were changing.

Residualisation and decline

The Byker estate was completed just in time for the onslaught of Thatcherism – or rather not quite completed as the development of the last cleared sites was handed over to private firms to build low-cost houses for sale to existing council tenants or to people on the council waiting list.[52] These developments take no account of the design or layout of the Erskine scheme.[53]

Old Byker had been home to a poor but solid working-class community. The 1980s saw the disappearance of the old jobs in the shipyards and heavy industry and their replacement with rising unemployment and lack of hope. A generation was growing up with little stake in a society that had abandoned it, and with a growing drug culture. At the same time, better-off council tenants were becoming home owners under Thatcher's Right to Buy legislation, and the stock of good council housing was being rapidly reduced. Some Byker houses were sold under Right to Buy, but not many in such a poor area. However, reductions in social housing, and a political and economic system that favours home owners, have concen-

49 Erskine (1984), p 191
50 Ravetz, Alison (1984), 'Commentary on Byker' in Hatch (1984) (198–201), p 200
51 Forsyth, Brian A. (1980), 'Vandalism and community responsibility', *Housing* January 1980 (6–7), p 6
52 The developers built and sold the houses, and the council sold the land directly to the new house owners. There were also arrangements for shared equity. See *Evening Chronicle*, 3 April 1980, 3 December 1981, 25 May 1982 and 1 July 1982
53 Drage, Michael (2008), 'Byker: Surprising the Colleagues for 35 Years, a Social History of Ralph Erskine's Arkitektkontor AB in Newcastle', *The Twentieth Century Society Journal* 9, pp 160–161

trated those without money or hope disproportionately in the remaining social housing, and widened the gap between them and those who have achieved material success. Places such as Byker have become ghettos for many of those failed by society. This situation is not inevitable – it is the product of policy decisions.[54] Byker was envisaged as part of an egalitarian society that opened possibilities for everyone, but it soon found itself in a neoliberal society that emphasised individual advancement and had little time for those who had failed to earn money and take their first step up the property ladder. The annual Report for the local Advice Centre for 1985–86 recorded unemployment at 30% and rising, with many families dependent on benefits. It observed that the resulting increase in stress was being manifested in an increase in enquiries from people whose marriages had broken down.[55] And the anti-social behaviour of neglect by the authorities was increasingly being echoed by the anti-social behaviour of alienated youth.

By the mid 1990s, unemployment in Byker ward was still 27% (though this was by no means the worst in the city) and East End school results were significantly worse than the Newcastle average, which was itself significantly worse than the national average. A quarter of residents claimed that they did not feel safe living in Byker, and, although the levels of reported burglary were roughly equivalent to the city average, there was widespread under-reporting of crime through fear of victimisation. At the same time, there was an acknowledgement that the reality was not as bad as the image being portrayed in the media.[56] The council's 1997 Community Appraisal, from which these statistics have been

[54] An example of a very different housing model, which aimed to ensure that people did not gain material advantage through home ownership, is provided by the 'tenure neutral' policies followed in 1960s Sweden. See Kemeny, Jim (1981), *The Myth of Home Ownership: Private Versus Public Choices in Housing Tenure*, London: Routledge and Kegan Paul; Glynn (2009), pp 32–33

[55] Byker Advice and Resource Centre Annual Report 1985–86

[56] Local and national media had especially enjoyed reporting the criminal career of one particularly recalcitrant young thief whom they nicknamed 'Ratboy' after he was caught hiding in one of the ducts in the community heating scheme

taken, stressed that there was now a lack of community facilities, especially for young people: and one of the suggestions from a 'Community Safety Day' was that the hobby rooms 'be used for play instead of storage'.[57] Of course actual experience of Byker depended on individual circumstances and the immediate neighbourhood and neighbours, but, as one of the residents put it:

> It's about jobs, income, self respect and a stake in the future of our community. I don't own anything. I don't belong anywhere. I don't have any say in what happens to me or my family or kids or anything.[58]

Byker ward was the third most deprived in the city, and was third again in the 2004 Index of Multiple Deprivation, where it scored especially badly for employment, income, education skills and training, health and disability, and crime.[59]

Management and maintenance

The physical decay of the estate is not just the result of a bit of mindless vandalism by younger residents, but also of the more culpable vandalism of a neglectful and often callous bureaucracy. This was badly aggravated by Thatcherite spending restrictions (as well as Thatcherite disdain), but maintenance has always been underfunded – the *Architectural Review* had claimed that there was insufficient finance for Byker's maintenance as early as 1974.[60] Blame must also be laid firmly on the unresponsive and distant bureaucratic system that has suffocated so much of Britain's council housing. The care and joy that had gone into designing Byker's housing found no echo in its management.

Landscaping has been a repeated casualty. High-quality external spaces need investment in their maintenance. This was

57 Newcastle City Council (1997), 'A Community Appraisal for Byker Monkchester and Walker', p 53
58 *ibid.*, p 26
59 http://www.newcastle.gov.uk/your-council/statistics-and-census-information/index-multiple-deprivation-2004
60 Amery, Colin (1974), 'Byker by Erskine', *Architectural Review* 156, p 362

always a low priority for British housing estates, but since Thatcher's attack on council housing it has been reduced to a bare minimum. Anything that might be problematic or labour-consuming is simply removed. This has included many of the shrubs that helped give Byker's external spaces a sense of enclosure. Play areas have often become a source of conflict as they can be noisy and also attract children from further afield, including teenagers. Rather than attempt more creative solutions to these problems – such as providing enough alternative entertainment to prevent too great a concentration of activity – the response has often been to take the play equipment away altogether.

In her 1987 book, *Property Before People*, Anne Power outlined how, as council housing expanded, management issues tended to be sidelined in favour of the more glamorous construction process, leaving the resulting homes to be run and maintained by a plethora of different departments in the far reaches of our city halls, unapproachable by and unaccountable to most tenants.[61] Her alternative solutions included devolving powers to locally based offices that would be open all day to tenants, who would ideally also have a management role. A more recent study of tenant management organisations in practice suggests that these can be especially important in facilitating the smooth running of small repairs, cleaning and general maintenance; though not all places will have tenants ready or able to get so involved.[62] In line with their general approach, Erskine's office had suggested a form of tenant management for Byker,[63] but the council had not taken this up. Since 2004, Newcastle's council housing has been administered by an arm's-length management organisation, which set up a

61 Power, Anne (1987), *Property Before People: The Management of Twentieth-Century Council Housing*, London: Allen and Unwin
62 Cairncross, Liz, Morrell, Caroline, Darke, Jane and Brownhill, Sue (2002), *Tenants Managing: An Evaluation of Tenant Management Organisations in England*, London: Office of the Deputy Prime Minister; Glynn (2014)
63 Gracie (1984), p 196; Drage (2008), p 153

local office in the building that had been used by Erskine. However, this system has distanced housing management from more democratic council control and also separated it from the wider management of the estate. Power also argued that tenants should be free to personalise their homes, and she called for continuous planned programmes of renewal and maintenance, which would seem basic requirements of estate management but have not been implemented.[64]

Under neoliberalism, unequal societies are kept in check through mechanisms of fear and control. In Byker, security has been strengthened with the help of controlled-entry systems, the ubiquitous CCTV, and a team of community wardens tasked with working with residents to reduce vandalism and deter low-level crime. This has not gone uncriticised. For Colin Dilks, who lived in the Wall, the installation of CCTV exposed the gulf between the rhetoric of participation and the very limited reality. 'Residents came home to find cameras monitoring their social space', he wrote. 'Cameras appeared overnight with speakers and listening devices to monitor the communal spaces. In areas where neighbours formerly congregated they now felt uncomfortable.' When a small majority of residents were shown to favour removing the cameras from access balconies to entrance foyers, Street Wardens suggested that 'residents would be to blame "if an old woman is mugged on your landing"'.[65] Dilks also claims that it was the installation of CCTV at the Raby Cross shops and the consequent displacement of anti-social behaviour that had led to problems in nearby Bolam Coyne.[66]

[64] The recent programmes of improvement under Decent Homes legislation have highlighted not only lack of maintenance, but also lack of knowledge of the condition of millions of pounds worth of property and the homes of thousands of council tenants across the UK

[65] Dilks, Colin (2005?), 'Resident Participation: History Repeating Itself?', https://borg.hi.is/enhr2005iceland/ppr/Dilks.pdf, p 8

[66] Dilks (2005?), p 6. Coyne is a local word for corner

Community

This area is no stranger to hardship; but life goes on, and so, battered, bruised and changing, does the Byker 'community'. The community spirit of Old Byker has gone: but this was the product of a time when most people worked for the same industries, women washed the family laundry in the communal washhouse, and people shared because they all had very little. Communities have changed even where there hasn't been demolition. By all accounts, the layout of New Byker did encourage neighbourliness, as did the preservation of neighbourhood groups, even if that was not as pervasive as generally portrayed. Different areas vary, but places still have a good community spirit with people looking out for each other, and the garden squares are well used in summer, with barbecues and paddling pools.[67]

There are still families with several generations all living on the estate – and there are also newer residents, including young professionals renting houses sold under Right to Buy, and refugees of which some 200 plus have come from Africa.[68] Asylum seekers were housed in Byker under the government's dispersal programme from early 2000. Their first years as outsiders in a deprived and predominantly white area were very hard, but now many have chosen to settle, and others from surrounding areas who have achieved refugee status have chosen to move to Byker too. A lot of the asylum seekers originally came from places where neighbours were like close family, and they were anxious to get to know the people they were now living among in Byker. They set up African Community Advice North East (ACANE) to support the settlement of asylum seekers and refugees, but also to promote integration – especially through their community centre at Raby Cross, which acts as a meeting place. ACANE's computers are freely available to, and well used by, local young people of all backgrounds, who can

67 Discussion with Roberta Davidson at Byker YMCA, 27 January 2015
68 Estimated number from Gaby Kitoko at ACANE

also get advice on things such as CV writing, or just play table football, watch TV and have a cup of coffee.[69] Racism has reduced and a new multicultural generation is growing up together, but the rise of UKIP, with its anti-immigrant message, is worrying.[70]

Heritage listing and stock transfer

In the New Labour years, Newcastle City Council took a lead in instigating regeneration schemes based on 'engineered gentrification'[71] and in carrying out a new wave of mass demolitions in the name of 'Housing Market Renewal' and its local precursor 'Going for Growth'. It is hardly surprising, then, that in 1999, when faced with the decay of Bolam Coyne,[72] a group of seventeen Byker flats that had become vandalised and hard to let, the council voted for demolition. Their thinking was exemplified by the comment from the Housing Committee chairman that 'The place has lots of rabbit runs where hooligans create trouble'.[73] Perversely, this may have set in motion the saving of the estate. Councillors had failed to anticipate the architectural outcry generated by their decision, which catalysed a process that eventually, in 2007, resulted in the heritage listing of the whole of Erskine's Byker. In Byker, the heritage emphasis on buildings rather than people should – theoretically at least – work in the interests of the community, thanks to the importance attached to Erskine's original design philosophy to which any thought of rejuvenating the buildings in the absence of their occupants would be anathema.

69 Discussions with Gaby Kitoko at ACANE and with Roberta Davidson at Byker YMCA, 27 January 2015
70 The United Kingdom Independence Party came second in Byker ward in the 2014 council election, with 28% of the vote. Labour got 58%
71 Cameron, Stuart (2006), 'From Low Demand to Rising Aspirations: Housing Market Renewal within Regional and Neighbourhood Regeneration Policy', *Housing Studies* 21:1, p 14
72 Bolam Coyne has now been renovated and rejigged to suit modern housing preferences. It is interesting to see the importance that was given to the removal of the access balconies. I live in Dundee where shared access balconies (or *pletties*) are the generally unproblematic traditional arrangement. The Tyneside flats of Old Byker all had ground-level doors
73 George Allison, quoted in Hetherington, Peter, 'Architects fight to save dream homes from civic vandalism', *Guardian*, 8 October 1999

Around this time, work started on improvements to the buildings to bring them up to the new mandatory Decent Homes standards. But government funding restrictions meant that the council would never be able to pay for all that needed to be done. They started looking for new ownership models for the Byker housing that would bring in more money. After a failed bid for PFI funding (they lost out in competition with other areas that were pursuing demolition, which was the officially favoured approach) they opted for stock transfer of the estate to a Community Trust. This was approved by tenants' vote in July 2011 and the transfer took place in 2012. Government (Labour and then Conservative coalition) made sure that council and tenants had little alternative by promising to write off the large remaining construction debts, but making this contingent on transfer. In addition, UK law differs from the international norm by insisting that money borrowed by local authorities to invest in housing counts towards public-sector debt, whereas borrowing by housing associations does not. Although stock transfer remains a hugely contentious issue – and the council spent large sums on a pro-transfer campaign – opposition in Byker was relatively muted.[74] The Trust is now free to invest revenue from rent and any new development and to borrow against its assets. Their first annual report states that they will be investing £26 million over the first five years,[75] which at £14,500 per long-neglected home is not a huge sum of money. And ultimately they are expected to be self-financing.[76] (Although investment in decent housing and community facilities brings financial savings in other areas of social spending, this is never considered, even when all costs are paid by a local authority.)

74 Tenants were told that without transfer, spending would be 'limited to essential health and safety works and planned maintenance such as external painting', see *Backing Byker* 6, May 2011

75 Byker Community Trust (2014), *Building Byker's Future Together ... Our Journey So Far*, Newcastle: Byker Community Trust, p 3

76 Byker Community Trust (2012?), *Corporate Plan 2012–2015*, Newcastle: Byker Community Trust, p 7

The Community Trust is a not-for-profit organisation run by a board, but, as in all stock transfers, there must be concerns about lack of democratic accountability and the potential for domination by commercial interests, especially by its financial lenders. The Trust has, of course, been promoted as a vehicle for tenant participation, though experiences of previous stock transfers do not inspire confidence – and tenant involvement and management could have been promoted under council ownership without the risks attached to transfer. There are currently four tenants on the thirteen-member board, but tenant board members have to work in confidence and in the interests of the organisation and are not the same thing as tenant representatives. The pre-existing legal Tenants' Right to Manage was actually lost through the transfer.[77]

The Trust is based on site at Raby Cross, but without the 1970s optimism and social-democratic mindset of Erskine's office the chances of being able to replicate even the limited level of participation achieved in the construction do not look good. The participation industry has become well developed in recent years and tends to generate enough bureaucracy to discipline even the most sincere of paid employees as well as to wear down and neutralise any volunteer activists. The people of Byker were already wary and exhausted by failed promises. Ten years ago, Dilks observed that 'a decreasing number of residents are involved in numerous groups discussing the same issues over the years with little or no result to show for it'.[78] One resident summed up the sense of frustration: 'I'm bloody sick of being empowered. I wish someone would get on and do something'.[79] Relatively few tenants have

[77] Newcastle City Council (2011), *Your Byker Future: Official Offer Document*, Newcastle City Council, http://www.bykercommunitytrust.org/sites/default/files/Official%20Offer%20 Document.pdf, p19
[78] Dilks (2005?), p 5
[79] Quoted in Pendlebury, John, Townshend, Tim and Gilroy, Rose, 'Social Housing as Cultural Landscape: A Case Study of Byker, Newcastle upon Tyne', paper presented at the Forum UNESCO University and Heritage 10th International Seminar, Newcastle upon Tyne, 11–16 April 2005, revised June 2006, http://conferences.ncl.ac.uk/unescolandscapes/

paid the £1 membership that entitles them to attend Trust AGMs and vote for tenant board members; and although there are two Tenants and Residents Associations, the meeting I went to was attended by representatives of various official bodies and focused on resolving day-to-day problems (including acting as an additional unofficial clerk of works for the refurbishment work) rather than setting the agenda.

What is to be done?

Decades of poor management, underfunding, and now austerity have resulted in a poverty of expectation and an acceptance of second best among council-house tenants that would be anathema to Erskine's original concept of democracy and empowerment. Nevertheless, despite the shabbiness of neglect and the need for upgrading to modern standards of insulation, Byker's physical structures have borne up well, and the estate retains the potential to be as good a place to live in as the rigours of wider socio-economic pressures allow.

The strictures of the heritage listing will ensure a degree of quality and appropriateness in any new architectural work that is absent from most refurbishment – and open up possibilities for grant funding. Listing does not mean that a building needs to be set in aspic, and, indeed, Erskine himself was clear that the estate should evolve in line with changing demands from the people who live there.[80] He believed that changes and additions could be enriching provided they kept in style and were 'subject to gentle but firm leadership in a dialogue with the architect or an interested person from the client's organization'[81] – which is very much how a listing is meant to work. However, the recent demolition of the old Hare and Hounds pub in Raby Street, which, though not designed by Erskine,

files/PENDLEBURYJohn.pdf, p 6
80 Erskine (1977), p 74
81 Quoted in Egelius (1990), p 120

played a part in the overall planning concept, does not inspire confidence.

In addition, the spirit of the original design would demand an imaginative and community-centred response to new possibilities and ideas such as the green agenda. Social housing has the potential to adapt particularly well to growing environmental demands as it facilitates the co-ordinated and long-term planning and investment required to make best use of environmentally friendly technologies. One obvious focus in Byker must be the community heating system. A biomass boiler has recently been installed, but it is imperative that tenants get the ability to control how much heat they use, and not pay for more than this. Double glazing is being put in, but any improvements to the main building fabric to increase insulation will have to be done with care to avoid creating problems of condensation and rot – especially with timber-frame construction. Without more money there are unlikely to be more substantial changes in the near future.

The green agenda is generating renewed interest in possibilities for creating a 'complete and integrated environment for living' where people don't need to rely on the car. At the same time, Jan Gehl's ideas on pedestrianisation are influencing planners across the world, and the importance of creating spaces that facilitate meeting and social engagement is gaining a new recognition. For the Byker Trust to give in to demands to allow parking outside the houses would be to tail-end what is increasingly being recognised as a destructive and alienating practice. Instead, care needs to be taken to ensure that car-owners have a dedicated parking space and that drivers are unable to speed through the estate so that the pedestrianised spaces really are safe. With proper investment in landscaping and in maintenance, traffic separation can work well, as numerous Nordic housing estates testify. A weaker version of these ideas – with well planted 'pocket parks' and sculptural play

equipment – underlies the award-winning private housing beside Dunston Staiths in Gateshead, just up the river from Byker.[82] While Staiths South Bank is occupied by young professionals and there are few local facilities, it also has only 1.25 parking spaces per home, the same as Byker where only 38% of homes have cars.[83] Regeneration of the Byker landscaping will require the same degree of sensitivity and enjoyment as was shown in the design and implementation of the original scheme. Trees planted then are now grown tall, and decisions have to be made on how to preserve the mature and varied planting while reopening views from the flats. There is also scope for introducing further vegetable-growing areas, in addition to the existing allotment gardens. These can be particularly important in improving a low-cost diet as well as facilitating informal interaction with neighbours.[84]

There is clearly scope for improved community facilities, especially for young people who need to be provided with things they *can* do, not just told what they can't. The hobby rooms need to be made readily accessible,[85] and while some may be used for small

82 Hemingway, Wayne, online blog: https://waynehemingway.wordpress.com/2011/03/04/the-staiths-4-years-after-the-first-residents-moved-in/, and https://waynehemingway.wordpress.com/2013/05/13/the-staiths-southbank-gateshead-13-years-on/; Arts Council England (2007), 'The power of the barbecue: Consumer responses to Staiths South Bank', http://www.artscouncil.org.uk/publication_archive/the-power-of-the-barbecue-consumer-responses-to-staiths-south-bank/

83 2011 Census. The figure for Newcastle as a whole was 58%, and for England and Wales 74%. As a low-income community with low car-ownership and good public transport, Byker could benefit from the development of car pools that would allow non-car owners to have affordable access to a vehicle when they need it

84 The introduction of gardens and vegetables can have an even greater impact in estates that were previously devoid of greenery and lacked outside spaces conducive to informal meetings – as a growing number of examples demonstrate. See Women's Environmental Network and Sustain (2008), 'Growing Round the Houses: Food production on housing estates', http://www.wen.org.uk/wp-content/uploads/food_growing_social_housing.pdf

85 James Longfield, who is doing research looking at the hobby rooms, claims their use has been restricted by lack of access rather than lack of demand. He explains that rather than being managed by the tenants, as intended, they vanished into council bureaucracy, and now 'the majority of hobby rooms lie vacant, underused or simply used as an overspill for home storage, and a few have even been taken over as extra bedrooms by the neighbouring homes.' Early uses included sewing, pottery, photography, a local magazine and a mice club. See Longfield, James (2014), 'Shop Drawings: the in-situ drawing practices of the citizen architect', *Tracey* February 2014, http://www.lboro.ac.uk/microsites/sota/tracey/journal/insit/2014/PDF/James_Longfield-TRACEY-Journal-DIS-2014.pdf, p 3

workplaces, ownership should remain with the Trust. Such a resource, once lost, would not be easily recreated. Although small shops everywhere have succumbed to the competition of the big multiples, there must be opportunities for reopening some of the boarded-up shops in Raby Cross, and a regular market could also give this area renewed focus.

Newcastle City Council still has an important role to play, not least in the areas immediately adjacent to the estate. With the loss of some of the former industries there is potential to improve the river frontage and develop links between this and lower Byker, to the benefit of this part of the estate and also Raby Cross. And on the other side they need to address the bleak no-man's-land that still separates Shields Road and the Wall.

But …

But meanwhile, despite the major upgrading work, which has already started, and all the plans for the future, Byker has not escaped the ravages of austerity politics. The North East of England has been especially badly hit, and Byker was rated the second worst ward in Newcastle in the 2010 Index of Multiple Deprivation, when 54% of Byker children were living in poverty.[86] Like everyone on low incomes, residents are finding it increasingly difficult to make ends meet. The bedroom tax has hit some households especially hard, escalating rent arrears and pushing people to move if they can. This also means less rental income to invest in the housing stock, especially with bigger homes becoming harder to let.[87] At the same time, already sparse community services have been cut, and those organisations that remain don't have the security to make long-term plans.

86 Newcastle Future Needs Assessment, http://www.wellbeingforlife.org.uk/sites/www.wellbeingforlife.org.uk/files/Know%20Your%20Community%20-%20Byker%20ward.pdf. The Newcastle average was 30% and the national average 21%

87 Byker Community Trust (2014), p 23. (Since 2013, social housing tenants who receive Housing Benefit to help pay their rent and are deemed to have more bedrooms than they need have forfeited a percentage of their Housing Benefit)

And there is one last sting in the tail. Current legislation makes any real improvement to English social housing impossible. Every effort that succeeds in making an area more attractive increases the likelihood of homes entering the market sector through Right to Buy (or Right to Acquire for new Community Trust tenants) and being lost from the social-housing stock. An iconic estate, with views across the Tyne bridges, close to the city centre and the already gentrifying Ouseburn, can provide rich pickings for speculators. Without a change in the law, as is taking place in Scotland, the improvement of social housing becomes a labour of Sisyphus.

The neglect of our public housing has been indicative of our society's disdain for many of its residents. We need to fight for a more equal (and less materialistic) society and, hand in hand with this, we need to fight for better treatment of those who are least well off and who our society has left by the wayside. The Byker story shows the dangers of criminal levels of neglect and underinvestment and of bureaucratic managerialism, but it also allows a glimpse of what can be achieved by dedicated attention and local involvement, and by treating the people who live in public housing with respect. No one should be able to say, like a young woman interviewed by Sirkka-Liisa Konttinen on her recent return visit to Byker: 'People round here don't have the confidence, they don't think they deserve it.'[88]

[88] Konttinen (2009), p 143

Acknowledgements

With thanks to: Roberta Davidson, Gaby Kitoko, James Longfield, Andy McDermot, Daniel Mallo, Ken Milor, Euan Preston, Armelle Tardiveau, Sophie Yarker, the *Architectural Review*, Byker Community Centre, Byker Village Tenants and Residents Association, Byker YMCA, Byker Sands Centre Sure Start Culture Exchange Group, Newcastle City Library, and Tyne and Wear Archives..

An earlier version of this essay was given at a colloquium on *The Housing Crisis: Experience, Analysis and Response*, Birkbeck Institute for Social Research, London, 18 November 2011.

BYKER NEWCASTLE UPON TYNE

BYKER NEWCASTLE UPON TYNE

BYKER NEWCASTLE UPON TYNE

BYKER NEWCASTLE UPON TYNE

BYKER NEWCASTLE UPON TYNE

BYKER NEWCASTLE UPON TYNE

BYKER NEWCASTLE UPON TYNE

BYKER NEWCASTLE UPON TYNE

BYKER NEWCASTLE UPON TYNE

BYKER NEWCASTLE UPON TYNE

BYKER NEWCASTLE UPON TYNE

BYKER NEWCASTLE UPON TYNE

BYKER NEWCASTLE UPON TYNE

BYKER NEWCASTLE UPON TYNE

BYKER NEWCASTLE UPON TYNE

BYKER NEWCASTLE UPON TYNE

BYKER NEWCASTLE UPON TYNE

BYKER NEWCASTLE UPON TYNE

BYKER NEWCASTLE UPON TYNE

BYKER NEWCASTLE UPON TYNE

BYKER NEWCASTLE UPON TYNE

BYKER NEWCASTLE UPON TYNE

BYKER NEWCASTLE UPON TYNE

BYKER NEWCASTLE UPON TYNE

BYKER NEWCASTLE UPON TYNE

BYKER NEWCASTLE UPON TYNE

BYKER NEWCASTLE UPON TYNE

BYKER NEWCASTLE UPON TYNE

BYKER NEWCASTLE UPON TYNE

BYKER NEWCASTLE UPON TYNE

BYKER NEWCASTLE UPON TYNE

BYKER NEWCASTLE UPON TYNE

BYKER NEWCASTLE UPON TYNE

BYKER NEWCASTLE UPON TYNE

BYKER NEWCASTLE UPON TYNE

BYKER NEWCASTLE UPON TYNE

BYKER NEWCASTLE UPON TYNE

BYKER NEWCASTLE UPON TYNE

BYKER NEWCASTLE UPON TYNE

BYKER NEWCASTLE UPON TYNE

BYKER NEWCASTLE UPON TYNE

BYKER NEWCASTLE UPON TYNE

BYKER NEWCASTLE UPON TYNE

BYKER NEWCASTLE UPON TYNE

BYKER NEWCASTLE UPON TYNE

BYKER NEWCASTLE UPON TYNE

BYKER NEWCASTLE UPON TYNE

BYKER NEWCASTLE UPON TYNE

BYKER NEWCASTLE UPON TYNE

BYKER NEWCASTLE UPON TYNE

BYKER NEWCASTLE UPON TYNE

BYKER NEWCASTLE UPON TYNE

BYKER NEWCASTLE UPON TYNE

BYKER NEWCASTLE UPON TYNE

BYKER NEWCASTLE UPON TYNE

BYKER NEWCASTLE UPON TYNE

BYKER NEWCASTLE UPON TYNE

BYKER NEWCASTLE UPON TYNE

BYKER NEWCASTLE UPON TYNE

BYKER NEWCASTLE UPON TYNE

BYKER NEWCASTLE UPON TYNE

BYKER NEWCASTLE UPON TYNE

BYKER NEWCASTLE UPON TYNE

BYKER NEWCASTLE UPON TYNE

BYKER NEWCASTLE UPON TYNE

BYKER NEWCASTLE UPON TYNE

BYKER NEWCASTLE UPON TYNE

BYKER NEWCASTLE UPON TYNE

BYKER NEWCASTLE UPON TYNE

BYKER NEWCASTLE UPON TYNE

BYKER NEWCASTLE UPON TYNE

BYKER NEWCASTLE UPON TYNE

BYKER NEWCASTLE UPON TYNE

BYKER NEWCASTLE UPON TYNE

BYKER NEWCASTLE UPON TYNE

BYKER NEWCASTLE UPON TYNE

BYKER NEWCASTLE UPON TYNE

BYKER NEWCASTLE UPON TYNE

BYKER NEWCASTLE UPON TYNE

BYKER NEWCASTLE UPON TYNE